essentials

FASHION
SKETCHBOOK

A DESIGNER'S COMPANION

PETER PAUPER PRESS, INC.
RYE BROOK, NEW YORK

PETER PAUPER PRESS
Fine Books and Gifts Since 1928

Our Company

In 1928, at the age of twenty-two, Peter Beilenson began printing books on a small press in the basement of his parents' home in Larchmont, New York. Peter—and later, his wife, Edna—sought to create fine books that sold at "prices even a pauper could afford."

Today, still family owned and operated, Peter Pauper Press continues to honor our founders' legacy—and our customers' expectations—of beauty, quality, and value.

Designed by Margaret Rubiano

Illustrations © 2013 Amy Saidens/Art Rep NYC

Copyright © 2013 Peter Pauper Press, Inc.
3 International Drive
Rye Brook, NY 10573 USA
All rights reserved
ISBN 978-1-4413-1172-6
Printed in China

Published in the United Kingdom and Europe by
Peter Pauper Press, Inc.
c/o White Pebble International
Units 2-3, Spring Business Park
Stanbridge Road
Havant, Hampshire PO9 2GJ, UK

28 27 26 25 24 23 22

Visit us at www.peterpauper.com

Introduction

Create your own original designs with this sleek **Fashion Sketchbook**! Packed with fashion-proportional figures in varied poses, this journal will help you bring your inspirations to life. You'll also find templates for shoes and hats in the back of the sketchbook. Note: The figures (called *croquis*—the word rhymes with "smoky"—from the French meaning "to sketch, rough out, to crunch") will not show up when photocopied or scanned.

The sketchbook also includes helpful depictions of basic garments, size equivalent information, measuring tips, and industry terms and descriptions.

From understated effects to outrageous accents, let this **Fashion Sketchbook** help you render your vision. Consider the myriad choices in fabrics, forms, colors, themes, and details. What will be your defining style? Express it here.

Fashion is not something
that exists in dresses only.
Fashion is in the sky, in the
street, fashion has to do
with ideas, the way we live,
what is happening.

COCO CHANEL

Basic Garments
Outerwear

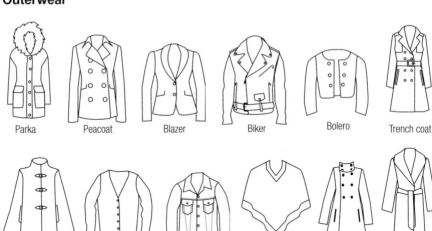

Parka Peacoat Blazer Biker Bolero Trench coat

Cape Cardigan Denim Poncho Swing coat Wrap coat

Shirts

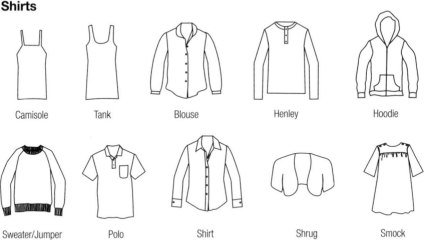

Camisole Tank Blouse Henley Hoodie

Sweater/Jumper Polo Shirt Shrug Smock

Tee Tunic Turtleneck Western Vest

Dresses

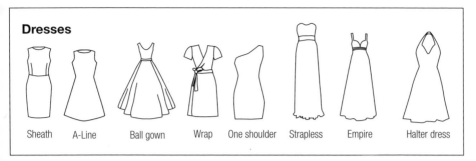

Sheath A-Line Ball gown Wrap One shoulder Strapless Empire Halter dress

Skirts

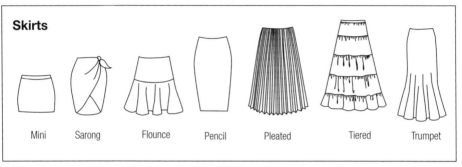

Mini Sarong Flounce Pencil Pleated Tiered Trumpet

Bottoms

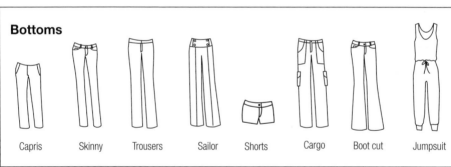

Capris Skinny Trousers Sailor Shorts Cargo Boot cut Jumpsuit

Hats

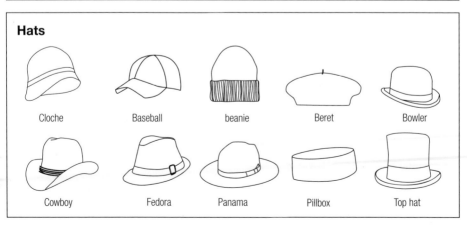

Cloche Baseball beanie Beret Bowler

Cowboy Fedora Panama Pillbox Top hat

Shoes

Ballet flat	Cowboy	Deck	Espadrille	Mary Jane
Moccasin	Pump	Sandal	Slingback	T-strap

Sample Patterns

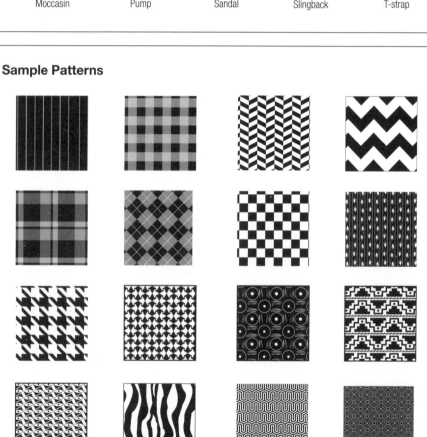

Size Equivalents

WOMEN'S STANDARD CLOTHING SIZES			
U.S.	U.K.	E.U.	ITALY
2	6	34	38
4	8	36	40
6	10	38	42
8	12	40	44
10	14	42	46
12	16	44	48
14	18	46	50
16	20	48	52
18	22	50	54
20	24	52	56
22	26	54	58

SHOE SIZES		
U.S.	U.K.	E.U.
6	4	36-37
7	5	37-38
8	6	38-39
9	7	39-40
10	8	40-41
11	9	41-42

HAT SIZES					
	U.S.	INCHES	U.K.	E.U.	CM
S	6-7/8	21-5/8	6-3/4	36	55
M	7	22	6-7/8	38	56
M	7-1/8	22-3/8	7	40	57
L	7-1/4	22-3/4	7-1/8	42	58
L	7-3/8	23-1/8	7-1/4	44	59
XL	7-1/2	23-1/2	7-3/8	46	60
XL	7-5/8	23-7/8	7-1/2	48	61

Body Measurement Standards in Inches							
U. S. SIZE	4	6	8	10	12	14	16
BUST	33-1/2	34-1/2	35-1/2	36-1/2	38	39-1/2	41
WAIST	25-1/2	26-1/2	27-1/2	28-1/2	30	31-1/2	33
HIP	35-1/2	36-1/2	37-1/2	38-1/2	40	41-1/2	43
Body Measurement Standards in Centimeters							
U. S. SIZE	4	6	8	10	12	14	16
BUST	86	89	91	94	98	100	104
WAIST	64	66	69	71	75	79	83
HIP	91	94	97	99	103	107	110

Note: Size measurements vary from source to source. Try on clothes when possible before you buy.

Measurements

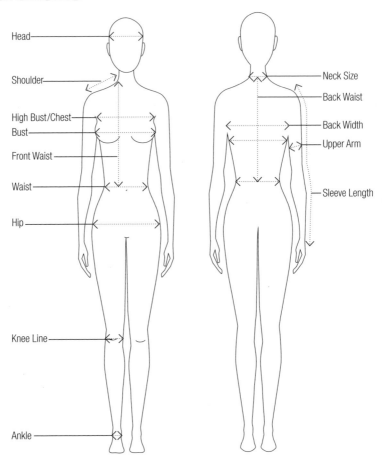

Head

Shoulder

High Bust/Chest

Bust

Front Waist

Waist

Hip

Knee Line

Ankle

Neck Size

Back Waist

Back Width

Upper Arm

Sleeve Length

- A friend is needed for some measurements, such as height and back waist. You'll also need a length of elastic.
- Take your measurements over the types of undergarments you plan to wear with the garments you are making.

Taking Your Measurements

1. For **height**, stand up straight against a wall. Have your friend measure from the floor to the top of your head.

2. To measure your **bust**, wrap your tape measure around the fullest point of the bust/chest and straight across the back. Keep tape snug but not too tight.

3. Run your tape measure around your body under your arms for your **high bust** or **chest** measurement.

4. Take your **waist** measurement: First, determine your natural waistline by tying a length of elastic around your waist. Move about for a bit to let it settle. Then wrap your tape measure around your body over the elastic. Leave the elastic on for the next two measurements.

5. Tilt your head forward and find the bone in your back that protrudes at the top of your spine. Have your friend measure from that point to the waistline elastic; this is your **back** or **back waist** measurement.

6. Take a **front waist** measurement by measuring from the high point shoulder (where your shoulder becomes your neck) down over the breast to your waist elastic.

7. For **sleeves**, measure from the edge of where your shoulder seam will be and along your arm to the place where the sleeve should end.

8. Take your **hip** measurement: Measure around the fullest part of your hips (while standing) and straight across your buttocks, usually about 7 to 9 inches below your waist.

9. Determine **skirt length** by measuring from the skirt design's waistline down to the place on your leg where the skirt will end.

10. Run your tape around the fullest part of your **upper arm** for that measurement.

11. Take an **inseam** measurement if you're making pants: Measure from your crotch to ankle bone or to the desired length of the slacks you're making. Or simply measure your favorite pair of pants.

12. To determine your **hat size**, measure the largest part of your head with tape above the brow.

My Measurements

Height

Head and neck

High bust/chest

Bust

Upper arm

Sleeve

Waist

Front waist

Back waist

Hip

Skirt length

Inseam

Fashion Glossary

Let this handy glossary acquaint you with selected fabric and fashion terms.

A-line skirt/A-line fit: A skirt or garment, fitted at the waist, and flaring to a flattering A-line or tulip shape at the hem.

acrylic: Synthetic, wool-like fabric often used in fleece.

appliqué: A cut-out decoration sewn to a larger piece of material. From the French for "applied."

ball gown: A formal-length evening dress with a full skirt.

Basque waist/V-waist: Dropped waist that starts at or just below the natural waistline and dips in the center, creating a "V" shape.

batik: A method of dyeing in which fabric is first coated with wax in the areas not to be colored, resulting in varying colors or patterns.

besom pockets: A pocket sewn inside the garment which is accessed via a seamed, slit opening.

bias cut: Cut diagonally across the grain of a fabric.

blazer: A long-sleeved sports jacket with lapels.

boat neck: A narrow, open neckline that runs across the front from shoulder to shoulder.

bodice: The part of a woman's garment extending from the neck and shoulders to the waist.

bolero jacket: A loose, waist-length jacket open at the front.

boot-cut: Jeans and trousers that flare from knee to ankle to accommodate boots and other footwear.

bouclé: A knit or woven fabric with a knotted, looped, nubby surface, often used in sportswear and coats.

boyfriend cut: Women's garments cut with a relaxed, loose fit.

boy-leg: Garments with close-fitting legs reaching to the thigh.

broomstick: A skirt or dress of crinkled, pleated fabric.

camisole or cami: Short sleeveless undergarment with spaghetti straps extending to the waist.

canvas: A sturdy, closely woven, medium to heavyweight cotton fabric.

cap sleeve: A very short sleeve that extends just over the shoulder.

Capri pants: Cropped pants that extend to the mid-calf, named after the Island of Capri, Italy.

cardigan: A sweater/jacket, often collarless and open in the front.

cargo: Loose-fitting pants or shorts with large patch pockets, usually with flaps.

carpenter: Functional pants with storage pockets and loops for holding tools. Traditionally used by carpenters and other tradespersons.

cashmere: A luxurious fiber of downy soft wool from the Cashmere (or Kashmir) goat.

cathedral train or monarch train: Very formal flowing train extending several feet beyond the gown.

chambray: A lightweight, plainly woven cloth, often of cotton.

Chantilly lace: A delicate lace created with thread and ribbons. Originally produced in Chantilly, France.

charmeuse: A smooth, satiny silky-like fabric.

chemise: Loose-fitting, straight dress or undergarment, extending to the mid-thigh, with spaghetti straps.

chenille: Fabric with patterns of velvety, fuzzy yarns (or the yarns themselves), often used for bedspreads.

chiffon: Sheer or filmy lightweight fabric comprised of twisted filament yarns.

chintz: Printed cotton fabric, usually glazed.

convertible collar: A rolled collar attached to the neckline. May be worn open or closed.

corduroy: Soft, durable cotton fabric with vertical ribs.

cotton: A popular natural fiber that comes from the white, downy substance surrounding the seeds of the cotton plant.

cowl neck: Extended, flowing collar draped loosely from the neckline.

crepe: Lightweight fabric with crinkled, puckered surface.

crew neck: A plain round neckline close to the base of the neck.

crinoline: Skirt or undergarment stiffened to support the skirt shapes of the 19th century; a stiffened fabric used for linings, or a hoopskirt.

crocheted: Loose, intertwined stitching made by looping yarn or thread with a hooked needle.

cropped top/jacket: A short garment; the hem is cut just above the waist.

denim: Durable cotton twill fabric, traditionally blue, for jeans and other garments.

dolman sleeve or batwing sleeve: A sleeve designed with a deep armhole that tapers to a close-fitting wrist.

double-breasted: Garment having half of its front lapped over the other half, usually with a double row of buttons and a single row of buttonholes.

dropped shoulders: Shoulder/sleeve seams that fall below normal shoulder seams.

dropped waist/low waist: Waistline below the body's natural waistline.

embroidery: Patterns of colored threads sewn to create a design. Embroidery may be done by hand or machine.

empire waist: A waistline beginning just below the bust, producing a sweeping, flattering garment.

faille: Shiny, soft ribbed fabric of silk, cotton, or manufactured fibers.

fitted-point sleeve: A long sleeve that tapers to a point on the back of the hand.

flannel: Soft, warm fabric finished with a light napping.

fleece: A soft, deep-piled woolen fabric, often used for linings.

frog closure: Ornamental button-and-loop closure made of cord or braid.

gabardine: A firm but lightweight twilled fabric often used for business suiting.

gaucho: Wide-leg, calf-length pants or a divided skirt worn with boots. Named after South American cowboy trousers.

gauze: Thin, sheer plain-weave fabric made of natural or synthetic fibers.

gingham: Check- or plaid-patterned cotton fabric.

halter top: Sleeveless top with a wrap neck tied in the back.

handkerchief style: A softly "jagged" hemline of a blouse or skirt that creates a flattering, flowing effect.

Hollywood waistband: Vintage waistline treatment with a full elasticized back and side zipper/button closure, creating a streamlined silhouette.

hook and eye closure: A two-part fastening consisting of a hook that catches in a matching eye loop.

houndstooth: A textile pattern of small broken checks.

intarsia: A decorative design knitted on both sides of a fabric.

jacquard: A decorative woven fabric (as opposed to having a design printed on a fabric).

jersey: Soft, breathable, plain fabric that is knit instead of woven.

jewel neck: A high round collarless neckline at the base of the neck.

kangaroo pocket: A pocket made of a cloth piece sewn atop the center portion of a garment, with two open ends.

keyhole neck: A teardrop- or round-shaped cutout on the front or back neckline.

kimono: Wraparound jacket/robe or gown with wide sleeves, tied with a sash.

knit: Fabric made from interlocking yarns/threads.

lace: A delicate, decorative needle-worked fabric made with threads, generally used for trimming.

lamé: Fabric interwoven with metallic threads, such as silver or gold.

leather: Animal skin processed and made supple for use in clothing and accessories.

leatherette: Simulated leather material.

linen: Fabric made from fibers derived from the flax plant. Linen is cooler and stronger than cotton.

Lycra: A synthetic stretchy spandex fiber.

madras: Lightweight cotton or other fabrics in brightly colored plaid patterns.

maillot: A flattering woman's one-piece bathing suit. Pronounced "my oh."

mandarin collar: A short, stand-up Asian-style band collar.

mermaid: A skirt that closely fits the body to the knees, then ends in a flare.

mesh: Knitted, woven, or crocheted fabric with a net weave.

microfiber: A fine, soft polyester.

muslin: A plain-woven fabric of cotton and or polyester blends.

nylon: Synthetic fiber known for strength and stain resistance.

off-the-shoulder neck: A neckline constructed so it lies across the top of the bust with shoulders uncovered.

organza: Sheer, crisp dress fabric of silk, nylon, or rayon.

peasant: A fashion style that often comprises ruffles, puckers, and low necklines, as well as natural, free-flowing fabrics. Peasant chic was made popular in the 1970s by Yves St. Laurent.

pencil skirt or column skirt/straight skirt: Straight skirt with no flare or fullness at hem or waistline.

peplum: A short fabric flounce attached to the waistline of a blouse, jacket, or dress; it creates a flared look.

petticoat: An underskirt, often full and trimmed with ruffles or lace.

picot: Tiny decorative, looped edging along fabric, ribbon, or lace.

pima cotton: A strong superior grade of cotton first developed in Pima County, Arizona, from Egyptian cottons.

pinafore: An overgarment originally intended to protect clothing, like an apron. Later worn to complement an outfit or as a sleeveless dress.

placket: The openings in skirts, trousers, or at necks and sleeves, etc., that allow you to put on or remove garments easily.

pointelle: Delicate, tiny, openwork designs in fabrics, especially knits.

polyester: Synthetic fiber possessing strength and wrinkle-resistance.

poplin: A strong plain-weave fabric with crosswise ribs.

princess seams: Seams in the front or back of a woman's garment that result in a form-fitting shape.

puckered bodice: Gathered folds that produce a "scrunchy" effect.

puff sleeve or pouf sleeve: Full, puffy sleeve. Lengths vary.

ramie: A strong, woody fiber from the stalk of a plant grown in Asia.

rayon: A manufactured fiber of regenerated cellulose. Known for its sheen and draping quality.

ribbing: Knitted ridges, usually vertical.

romper: A one-piece jumpsuit-style garment that combines the top with shorts or trousers.

sarong: Length of cloth wrapped around the body to form a dress or skirt.

satin: A lustrous fabric with a dull backing, often used for evening and wedding garments.

scoop neck: A low round or U-shaped neckline.

seersucker: Puckered light fabric of rayon, cotton, or linen, favored for warm weather wear.

sequined: Ornamented with tiny discs of shining metal or plastic.

shawl collar: A one-piece collar turned over to form a continuous curved line around the neck.

sheath: A close-fitting dress, usually knee-length.

sheer: Extremely lightweight fabric such as chiffon, voile, or sheer crepe.

shelf bra: A bra built right into the garment.

shirred: Gathered rows that form decorative pleating.

shrug: Very short sweater/jacket, often fastening below the bust.

silk: A soft, radiant natural fiber produced from the threads of insect larvae.

skort: A pair of shorts with a front fabric covering, making the garment resemble a skirt.

spaghetti straps: Very thin straps attached to a bodice.

Spandex: A synthetic fiber popular for its elasticity. Also known as Lycra.

square neck: A neckline shaped in the form of a half square.

straight legs: Figure-flattering pants cut an equal width from the waist to the ankles.

suede: Leather fabric with a napped surface.

sweep train: The shortest train, barely sweeping the floor.

sweetheart neckline: Curved neckline with a scalloped trim.

taffeta: A smooth, lustrous plain-weave fabric used for gowns and corsets.

tankini: A two-piece bathing suit with a top that resembles a tank top.

tapered legs: Pant legs that become narrower from waist to ankle.

tea length: A gown hemmed to end at about mid-calf length.

terry or terry cloth: Thick, absorbent, fabric, usually cotton, with loop pile on one or both sides.

trapeze top: An easy-fitting blouse or tank-style top with a flared bottom.

tulle: Very fine netting, often stiffened, for use in veils, gowns, etc. The name comes from Tulle, France.

tunic: A simple slip-on garment. Can be made with or without sleeves, can be knee-length or longer, may or may not be belted, and can be worn as an under or outer garment.

turtleneck: High, close-fitting collar that is turned over under the chin; used especially for sweaters.

twill: A weave of diagonal parallel ribs used in denim, chino, gabardine, and similar fabrics.

unitard: A snug one-piece garment with legs, feet, and often arms. Worn by acrobats and gymnasts.

variegated: Having different colors.

velour: A stretchy fabric with a thick, plush pile resembling velvet.

velvet: Fabric with a short, dense, brushed pile that offers a plush feel.

voile: A soft, thin, sheer fabric of cotton, silk, or rayon. From the French for "veil." Often used for warm-weather clothing and curtains.

wedding-band collar: A high, close-fitting collar that presents a choker effect.

wool: Thick, heavy natural fiber or fabric usually made from the undercoat of sheep or goats.

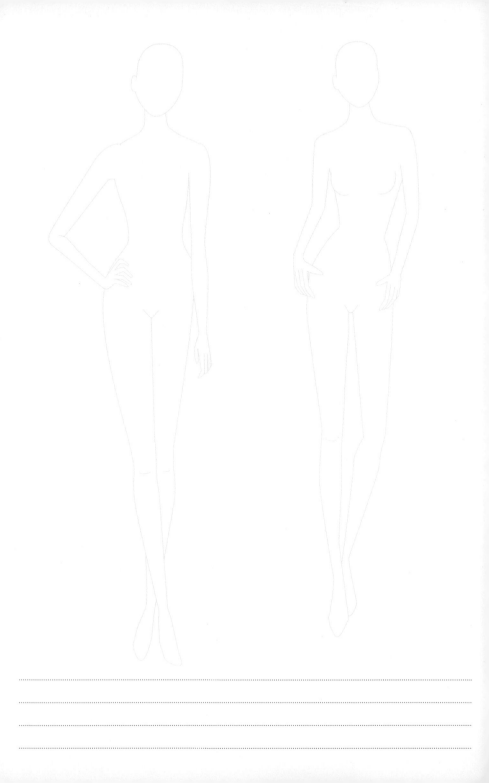

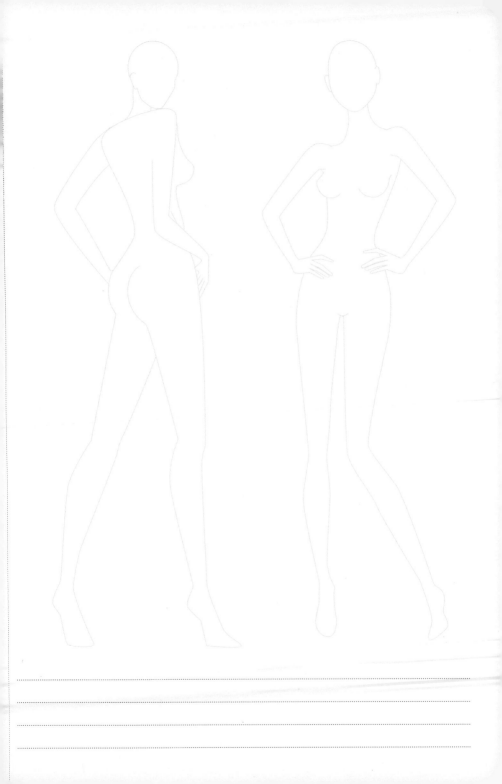